Charlotte

and the State of NORTH CAROLINA

It's old
with lots of new!

It's fun
and friendly, too!

NORTH CAROLINA
Charlotte

The places where you live and visit help shape who you become. So find out all you can about the special places around you!

Cool Stuff™

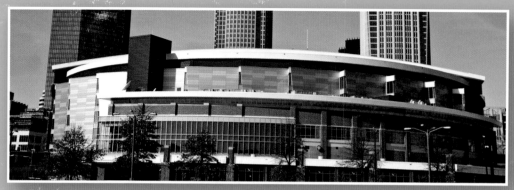

The Time Warner Cable Arena is home to the Charlotte Bobcats.

CREDITS

Series Concept and Development
Kate Boehm Jerome

Design
Steve Curtis Design, Inc. (www.SCDchicago.com); Roger Radtke, Todd Nossek

Reviewers and Contributors
Laura Hill, Marketing/Communications Manager, Charlotte Regional Visitors Authority; Connie Bodner, Ph.D, senior researcher; Judy Elgin Jensen, research and production; Mary L. Heaton, copy editor

Photography
Cover(a), Back Cover(a), i(a), ii, iii, xvi(b) © Jill Lang/iStockphoto; Cover(b), Back Cover(b), i(b) © Alhovik/Shutterstock; Cover(c), *Sights and Sounds* (c) © Leighton Photography & Imaging/Shutterstock; Cover(d), *By The Numbers* (b) © Tais Melillo; *Spotlight* (background) © Filipe B. Varela/Shutterstock; *Spotlight* (a) © Bill Cobb/Urban-Photos.com; *Spotlight* (b) © William Warner/Shutterstock; *By The Numbers* (a), *Sights and Sounds* (e), *Sights and Sounds* (f), xvi(a) © Mark Clifton; *By The Numbers* (c), *Marvelous Monikers* (b) Courtesy Visit Charlotte; *By The Numbers* (d) Courtesy Carolina Raptor Center/www.carolinaraptorcenter.org; *Sights and Sounds* (a), xvi(d) Courtesy Carowinds; *Sights and Sounds* (b), xvi(h) © John A. Anderson/Shutterstock; *Sights and Sounds* (d) Courtesy Discovery Place; *Strange But True* (a, c) © Nancy Pierce; *Strange But True* (b) © Steve Byland/Shutterstock; *Strange But True* (c), *Dramatic Days* (b), xvi(g) © Jill Lang; *Marvelous Monikers* (a) © Steve Moore; *Marvelous Monikers* (c) ttueni/Shutterstock; *Marvelous Monikers* (d) © Iurii Konoval/Shutterstock; *Dramatic Days* (a) From Wikipedia; *Dramatic Days* (c) NOAA/Satellite and Information Service/from Wikimedia; xvi(e) © PeterPhoto/iStockphoto; xvi(f) © David Powers/iStockphoto

Illustration
i © Jennifer Thermes/Photodisc/Getty Images

ISBN 978-1-4396-0097-9

Library of Congress Catalog Card Number: 2010935887

Published by Arcadia Publishing, Charleston, SC

For all general information contact Arcadia Publishing at:

Telephone 843-853-2070

Fax 843-853-0044

Email sales@arcadiapublishing.com

For Customer Service and Orders:
Toll-Free 1-888-313-2665

Visit us on the Internet at www.arcadiapublishing.com

Table of Contents

Charlotte

Spotlight on Charlotte

By the Numbers

Sights and Sounds

Strange But True

Marvelous Monikers

Dramatic Days

North Carolina

What's So Great About This State ... 1

The Land .. 2

 The Coastal Plain .. 4

 The Piedmont .. 6

 The Mountains .. 8

The History ... 10

 Monuments .. 12

 Museums ... 14

 Plantations .. 16

The People ... 18

 Protecting .. 20

 Creating Jobs .. 22

 Celebrating .. 24

Birds and Words .. 26

More Fun Facts .. 28

Find Out More .. 30

North Carolina: At a Glance .. 31

Spotlight on Charlotte!

Charlotte is the largest city in the state of North Carolina. It's located in the south-central area of the state near the South Carolina border.

 Q: How many people call Charlotte home?

 A: The population within city limits is around 750,000. But more than 1,800,000 people live in the area including Charlotte, Gastonia, and Rock Hill, South Carolina.

Q: Are there any sports teams in Charlotte?

 A: Absolutely! Charlotte fans cheer for such teams as the Carolina Panthers (NFL football) and the Charlotte Bobcats (NBA basketball).

Q: What's one thing every kid should know about Charlotte?

 A: In 1755 Thomas Polk settled at the crossroads of two Native American trading paths. The area soon became the village of Charlotte Town and, eventually, the leading banking and financial city that is present-day Charlotte.

 You can play checkers on the front porch of an old mill house at the Levine Museum of the New South.

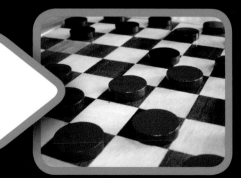

Charlotte...

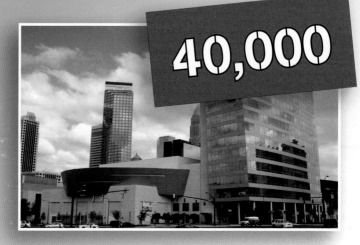

40,000

The NASCAR Hall of Fame devotes about 40,000 square feet of exhibit space to explaining the history and heritage of the sport. (The first NASCAR stock car race took place in Charlotte on June 19, 1949.)

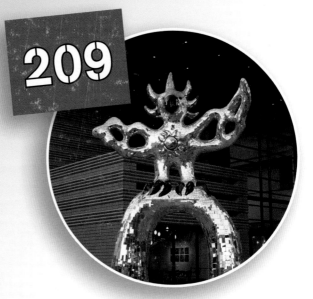

209

The *Firebird* sculpture stands 209 inches (or 17 feet, 5 inches) tall on the plaza of the Bechtler Museum of Modern Art. Pieces of mirrored and colored glass give the interesting birdlike sculpture a real shine!

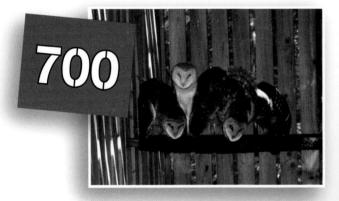

12,000,000

The U.S. National Whitewater Center actually makes its own whitewater rapids—using huge pumps that circulate 12 million gallons of water through the park. Even if you're not into rafting, there's still plenty to do at this outdoor adventure center, from rock climbing to zip lining to mountain biking along the Catawba River.

700

According to the Carolina Raptor Center, which is located near Charlotte, approximately 700 injured or orphaned raptors (birds of prey) are brought to their Jim Arthur Raptor Rehabilitation Center each year. Volunteers help care for the birds while they recover. The ultimate goal is to release as many birds as possible back into the wild.

More Numbers!

600	The number of exterior LED lights on the Duke Energy Center that put on a colorful light show each night.
32	According to its web site, more than 32 million passengers travel through the Charlotte Douglas International Airport each year.
1992	In that year, lights were installed around the track at the Charlotte Motor Speedway—and night racing began!

By The Numbers

Charlotte: Sights and Sounds

Hear

…the fun-filled screams of visitors on the roller coasters and thrill rides at Carowinds amusement park. (The name Carowinds is a blend of the two words "Carolina" and "winds.")

Smell

…the orchids growing in the McMillan Greenhouse at the UNC Charlotte Botanical Gardens. (This is also where "Bella"—the stinky corpse flower that blooms only once every few years—grows.)

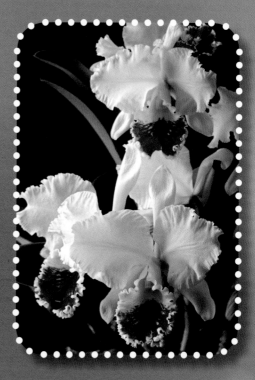

See

...free-flying butterflies at the Butterfly Pavilion at the Charlotte Nature Museum.

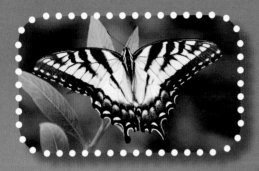

...the Hezekiah Alexander House when you visit the Charlotte Museum of History. This rock house, built around 1774, is the oldest surviving house in Mecklenburg County.

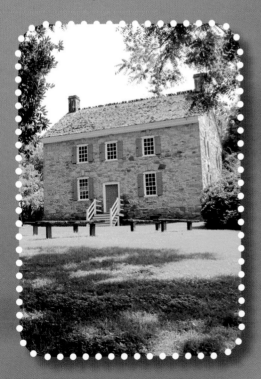

Explore

...the amazing science exhibits at Discovery Place. An aquarium, 3D Theatre, and IMAX Dome add to the fun.

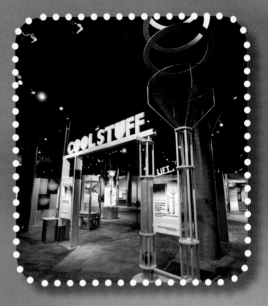

...the Harvey B. Gantt Center for African-American Arts + Culture, which presents, preserves, and promotes African American art, culture, and history. (It's part of the great Levine Center for the Arts.)

Sights and Sounds

STRANGE BUT TRUE!

THE MISSING DOC

Every May 20, Charlotteans celebrate Meck Dec Day. It honors the 1775 signing of the Mecklenburg Declaration of Independence, a document that may—or may not—have existed. (The original was supposedly destroyed in a fire, and a copy has never been found.) Even so, Charlotte's revolutionary message was made clear in the Mecklenburg Resolves (laws for governing the free) that Captain James Jack delivered by horseback to the Continental Congress in Philadelphia.

A FEATHERED FRIEND

Elizabeth Clarkson and Elizabeth Lawrence started wonderful gardens that are now part of the Wing Haven Gardens and Bird Sanctuary. Although both loved nature, Elizabeth Clarkson especially loved birds. She once rescued a family of orphaned bluebirds and the one she named Tommy flew in and out of her house for its entire life. Tommy didn't like to bathe in outside bird baths like the bluebird in the picture. He preferred to splash in a soup bowl in the Clarkson's bathroom—or dive into finger bowls on the dining room table!

WHICH CHARLOTTE?

A clever public art signpost at The Green, a fun park in Uptown Charlotte, shows the distances to a variety of other cities with the same name. According to the artwork, Charlotte, Iowa is 940 miles away. Charlotte (Waters), Australia? A whopping 9,975 miles!

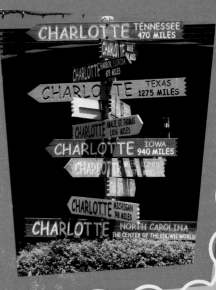

Strange But True

Charlotte: Marvelous Monikers

What's a moniker? It's another word for a name...and Charlotte has plenty of interesting monikers around town!

NoDa

A Name for Art

NoDa (short for North Davidson Street) is an area in the historic neighborhood of North Charlotte. Once dominated by textile mills, the NoDa area is now a lively arts district.

ImaginOn

A Storytelling Name

ImaginOn brings stories to life as a library and children's theater all rolled into one.

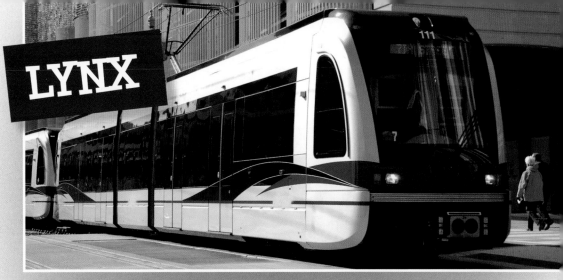

LYNX

A Name to Ride

The **LYNX** moving around Charlotte is not a four-footed animal; it's a light rail line that carries thousands of people around the city. By the way, the trains of the LYNX are run by CATS (the Charlotte Area Transit System).

Lazy 5 Ranch

A Name for Adventure

Want to see some real animals? Take a "car safari" through the **Lazy 5 Ranch** near Charlotte. It's home to more than 750 animals from all over the world!

Queen City

A Lot of Nicknames

The city was named for Queen Charlotte, wife of British King George III, so **Queen City** is a nickname. But the city also earned the nickname *Hornet's Nest* for driving out British troops during the American Revolution. (*City of Trees* and *City of Churches* are other common nicknames.)

Marvelous Monikers

Charlotte:
DRAMATIC DAYS

A BIG Find!

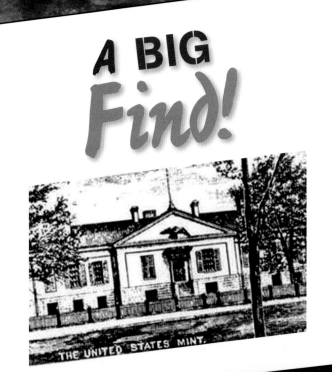

THE UNITED STATES MINT.

It seemed like an ordinary day in 1799 when twelve-year-old Conrad Reed went fishing in Little Meadow Creek on his family's farm in Cabarrus County. But he brought home a shiny 17-pound rock that soon changed the entire region. Although the family first used it as a doorstop, the rock was eventually recognized as a nugget of real gold! Soon after, the country's first official gold rush was on. Miners flocked to North Carolina and a branch of the U.S. Mint was opened in Charlotte to help turn the gold into coins.

A Tragic End!

In April of 1865—in the closing days of the Civil War—Confederate President Jefferson Davis arrived in Charlotte with about a thousand cavalrymen. During his stay, Davis was giving a small speech when he was interrupted with a telegram that informed him of President Abraham Lincoln's assassination. A plaque in the sidewalk near the corner of South Tryon and 4th Street marks the place where Davis was standing when he heard the tragic news.

JEFFERSON DAVIS WAS STANDING HERE WHEN INFORMED OF LINCOLN'S DEATH APRIL 18,1865

A Huge Storm!

On September 22, 1989, Hurricane Hugo—by then weakened to a tropical storm—roared by Charlotte, bringing hurricane-force gusts of wind with it. (Since Charlotte is approximately 200 miles inland, it was unusual for the storm to remain that strong over land for so long.) Most residents were left without electrical power for weeks, and property damage was severe. It's estimated that 80,000 trees were destroyed. Needless to say, the cleanup took months!

Dramatic Days

Congratulations!

You have just completed a kid-sized tour of Charlotte... but there's more to explore!

The city of Charlotte is an important part of the state of North Carolina. Why? It's because the city helps shape the state and the state helps shape the city!

Read on to find out more...

North Carolina

What's So Great About This State?

There is a lot to see and celebrate...just take a look!

CONTENTS

Land .pages 2–9
History. .pages 10–17
People .pages 18–25
And a Lot More Stuff!.pages 26–31

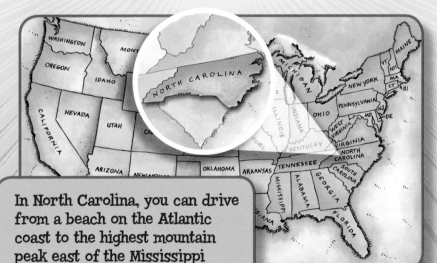

In North Carolina, you can drive from a beach on the Atlantic coast to the highest mountain peak east of the Mississippi River in less than a day.

Well, how about...
the land!

From the Beaches...

North Carolina is a beautiful state with more than 52,000 square miles of land. On the eastern side of the state, most of this land sits right at sea level. Why? It's because the Atlantic Ocean forms the eastern border of the state.

Millions of people enjoy the wonderful beaches along the barrier islands and sounds, or inlets. However, most of the state's population lives farther west in the middle part of the state. Here, gently rolling hills slowly begin to rise in elevation.

North Carolina beaches are beautiful summer vacation spots. Commercial and sport fishing are also big activities along the coast.

Tar from the pine trees that grow throughout North Carolina was an important part of the state's early economy and gave rise to the nickname the Tar Heel State (that really began to "stick" after the Civil War).

...To the Mountains

The huge 1,500-mile Appalachian Mountain range passes through the western part of North Carolina. This means that the Tar Heel State has many mountains—including the famous Blue Ridge and Great Smoky mountain chains. The highest mountain peak in the state, Mount Mitchell (elevation 6,684 feet), is also the highest peak east of the Mississippi!

North Carolina has amazingly beautiful land. So take a closer look at the next few pages to get a "big picture" view. Then decide which areas you might want to explore some more.

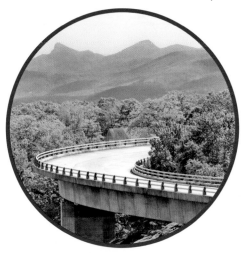

The Blue Ridge Parkway is a highway (with incredible engineering!) that winds through North Carolina's Blue Ridge Mountains.

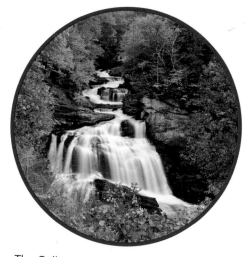

The Cullasaja Falls are in the Nantahala National Forest, which is the largest of the four national forests in North Carolina.

The Oconaluftee River flows through Great Smoky Mountains National Park in North Carolina.

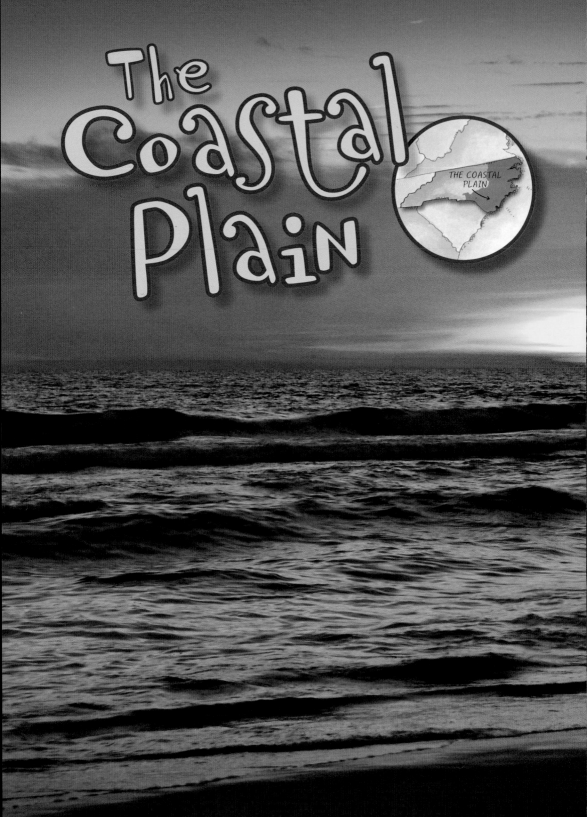

The Coastal Plain

THE COASTAL PLAIN

The sunrise is beautiful at Nags Head, North Carolina.

The Coastal Plain is the largest region in North Carolina. Three different areas—the Outer Banks, the Tidewater, and the Inner Coastal Plain—each contribute to the unique character of this region.

What's so special about the Outer Banks?

The Outer Banks protect much of the North Carolina coastline from the crashing waves of the open sea. Over one hundred miles of barrier islands form the easternmost part of the Outer Banks. Three areas that jut out from the mainland, called capes, are also part of the Outer Banks. Cape Hatteras, Cape Lookout, and Cape Fear are known for both their beauty and their dangerous underwater shifting sands.

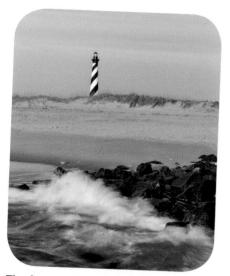

The famous Cape Hatteras Lighthouse shines a light that can be seen twenty miles out at sea.

So where is the Tidewater area?

The Tidewater starts just west of the Outer Banks. Much of this area is covered with wetlands. Many rivers and streams empty into the sounds, or inlets, of the Tidewater area. The Pamlico, Albemarle, Currituck, Croatan, Roanoke, Core, and Bogue Sounds are the seven sounds in the Tidewater.

The Tidewater also includes the Great Dismal Swamp. Its name doesn't sound very pleasant, but the swamp is home to a large variety of different kinds of mammals, reptiles, amphibians, and birds—not to mention insects and plants, of course.

...and there's more!

Just west of the Tidewater is the higher, drier land of the Inner Coastal Plain. Its rich, sandy soil forms some of the best farmland in the state.

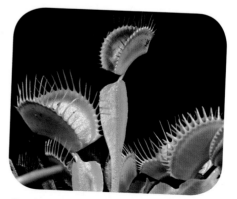

Carnivorous, or meat-eating, Venus Flytrap plants grow naturally in the North Carolina Tidewater.

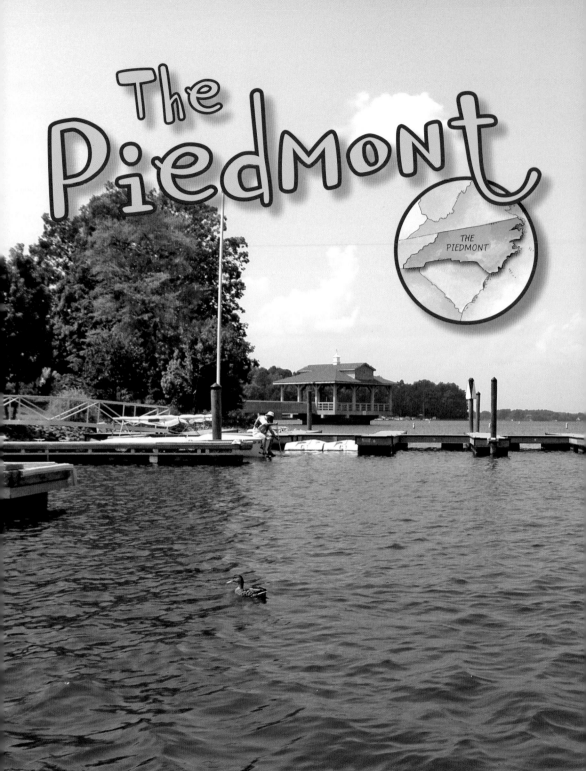

The Piedmont

THE PIEDMONT

Lake Norman is a large inland lake in the Piedmont region that has 520 miles of shoreline.

The Piedmont region lies in the middle of North Carolina. Piedmont means "foot of the mountain," and its land gently rises from about 300 feet on its eastern boundary to around 1,500 feet along its western boundary, which is closest to the mountains.

What's so special about the Piedmont region?

The rolling hills of the Piedmont are famous for their historic towns and golf courses. But there are also tobacco, cotton, and soybean farms as well as acres of vineyards in the region. The clay soil from some areas is used to make pottery. Minerals, including gold and emeralds, have also been found in this region.

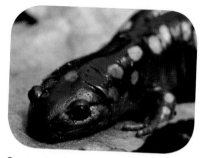

Spotted salamanders live in many parts of the state—including the Piedmont region.

What can I see in the Piedmont?

Well, one thing you can see is people! More North Carolinians live in this region than anywhere else in the state. Big cities such as Charlotte, Durham, Greensboro, and the state's capital, Raleigh, are found here. Many of the state's big universities are also in the Piedmont area.

Don't forget about the fall line!

The Piedmont region is separated from the Coastal Plain region by an imaginary fall line. The land to the west of the fall line is higher than the land to the east. As a result, waterfalls can occur in Piedmont rivers and streams as they "fall" onto the lower land of the Coastal Plain.

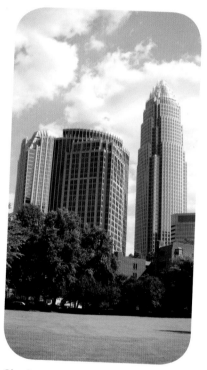

Charlotte, the largest city in North Carolina, is in the Piedmont region of the state.

The Mountains

THE MOUNTAINS

Mount Mitchell State Park has an icy look in the winter.

The Mountain region of North Carolina is the smallest region in the state in terms of area—but not in height! More than one hundred of its mountains rise to 5,000 feet, and more than forty mountains top 6,000 feet!

What's so special about the Mountain region?

Spectacular forests, amazing waterfalls, incredible peaks and cliffs—it's hard to describe the natural beauty of this region! Even the names of some of the mountain ranges are attempts to describe their unique look. The very dark evergreen forests along their peaks give the Black Mountains their name. The Blue Ridge Mountains appear to have a hazy blue look from a distance. And the higher elevations of the Smoky Mountains are often shrouded in fog, which makes them look as if they're surrounded by smoke.

Don't forget about the gorges! (...and what exactly is a gorge, anyway?)

A gorge is a deep and narrow channel with steep rocky sides that are carved out over a long period of time—often by the rushing water of a river. The Linville Gorge in the Pigsah National Forest and the Nantahala Gorge in the Nantahala National Forest are two big gorges in North Carolina. Many valleys, such as the beautiful Maggie Valley, are also sprinkled throughout the region.

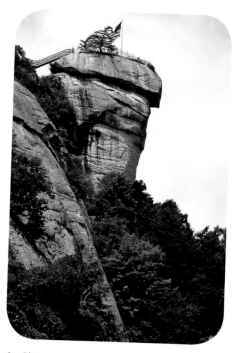

At Chimney Rock State Park, a 26-story elevator (built right inside the mountain!) takes visitors to the top of Chimney Rock for great views of Lake Lure and Hickory Nut Gorge.

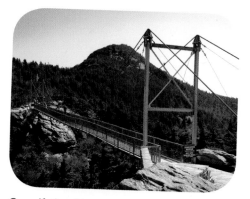

Grandfather Mountain's Mile-High Swinging Bridge is a mile above sea level—and swings over an 80-foot chasm, or drop.

9

Well, how about...

the history!

Tell Me a Story!

The story of North Carolina begins thousands of years ago. Following the tradition of their ancestors who first lived on the land, Native Americans made their home throughout the state. Most lived in groups called tribes, and each had its own culture.

Native Americans living in North Carolina in the 1500s included such groups as the Catawbas, Tuscaroras, and Algonquins. However, the mountain-dwelling Cherokees had the largest communities.

The Museum of the Cherokee Indian in Cherokee, North Carolina, tells a 10,000-year history of this amazing Native American culture. Tragically, in 1838 most of the Cherokee were forced out of North Carolina. Their thousand-mile journey to Oklahoma—now remembered as the "Trail of Tears"—cost many lives. However, the Cherokee Nation managed to survive and descendants still live in North Carolina today.

Constructed more than one hundred years ago, the Biltmore Estate in Asheville is still the largest privately owned home in the United States.

...The Story Continues

Eventually, Spanish, French, and English explorers came to North Carolina as well as other European and American settlers and African Americans. Through the years many battles for freedom were fought in North Carolina—from the French and Indian War to the American Civil War.

But history isn't always about war. North Carolinians have always educated, invented, painted, written, sung, and built. Many footprints are stamped into the soul of North Carolina's history. You can see evidence of this all over the state!

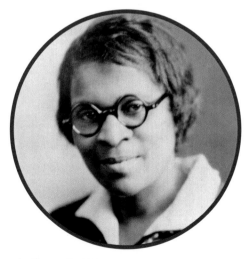

North Carolina's Halifax Resolves (April 12, 1776) were the first official act by any of the 13 colonies to call for independence from British rule.

In the early 1900s, Dr. Charlotte Hawkins Brown was the founder and leader of the Palmer Memorial Institute, a school for African American students.

MonumentS

1795 1849
JAMES KNOX POLK
OF
MECKLENBURG COUNTY

PRESIDENT
1845—1849

HE ENLARGED OUR

1767 1845
ANDREW JACKSON
OF
UNION COUNTY

PRESIDENT
1829—1837

HE REVITALIZED

1808 1875
ANDREW JOHNSON
OF
WAKE COUNTY

PRESIDENT
1865—1869

HE DEFENDED

Autumn leaves fall on this statue in Union Square in Raleigh which
honors the three presidents who were born in North Carolina—
James Polk, Andrew Jackson, and Andrew Johnson.

NO CLIMBING
ON STATUES

Monuments and historic sites honor the special people and events that helped shape the state of North Carolina—and the nation.

What kind of monuments can I see in North Carolina?

There are many different kinds. From statues to bridges to street signs and fountains, almost every town has found some way to honor a historic person or event.

Where are monuments placed?

Almost anywhere! A plaque on top of Mt. Mitchell honors its namesake—the Reverend Elisha Mitchell.

What about historic sites?

North Carolina has plenty! For example, the Carl Sandburg Home is a historic site located on 264 acres in western North Carolina. It was the first historic site to honor an American poet.

The Duke Homestead in Durham is another historic site. It allows visitors to see the early farm and factory where Washington Duke first grew and processed tobacco.

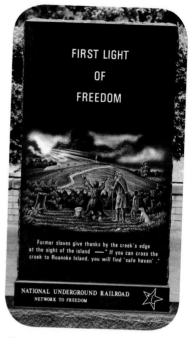

The Freedmen's Colony Monument on Roanoke Island pays tribute to African Americans who escaped from slavery to begin a new life during the Civil War.

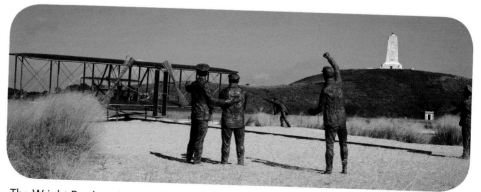

The Wright Brothers National Memorial in Kill Devil Hills honors the brothers' first successful airplane flights in 1903. Interestingly, Orville and Wilbur had a business selling, repairing, and manufacturing bicycles to pay for their flying experiments.

MuSeuMS

The North Carolina Transportation Museum in Spencer preserves the history of transportation in the state.

Museums don't just tell you about history—they actually show you artifacts from times past. (By the way, an artifact is any object that is actually produced by a human!)

Why are the museums throughout North Carolina so special?

North Carolina's museums contain amazing exhibits that tell the story of the state. For example, the North Carolina Museum of History in Raleigh has more than 250,000 historical items that piece together the state's history.

What can I see in a museum?

An easier question to answer might be "What can't I see in a museum?" Are you interested in fossils? The Aurora Fossil Museum has hundreds of whale and shark fossils. Visitors can even make their own discoveries by digging through the museum's special fossil pit.

The Franklin Gem & Mineral Museum displays another type of collection. It has beautiful precious and semiprecious stones—as well as a nice collection of Native American artifacts.

...and don't forget the kilts!

The Scottish Tartans Museum in Franklin tells the story of Scottish Highland clothing. This museum is located in North Carolina because the state is home to so many people of Scottish descent.

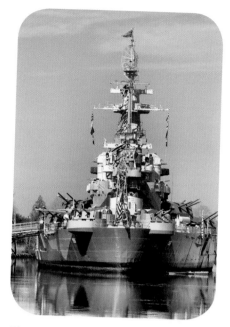

The *USS North Carolina* battleship rests as a floating museum at the port of Wilmington. This ship was a city at sea for two thousand sailors during World War II. Besides living, eating, and medical facilities, the ship even had such things as a movie theater and an ice cream shop.

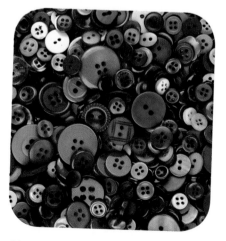

How many buttons do you have? The Belhaven Memorial Museum builds on the unique collections of Mary Eva Blount Way. Before she died, "Miss Eva" collected approximately thirty thousand buttons from all over the world!

Plantations

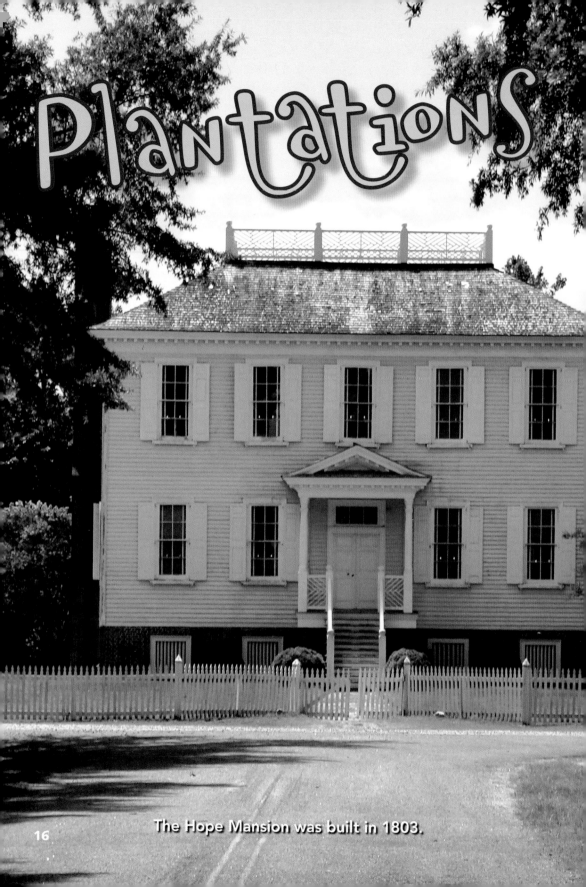

The Hope Mansion was built in 1803.

In the early 1800s, the Hope Plantation near Windsor, North Carolina had its own water powered grist mill, a blacksmith shop, and a cooper's shop. (Coopers made containers, such as barrels and buckets.)

Why are plantations special? (...and what is a plantation, anyway?)

Plantations were large estates or farms where crops such as rice and cotton were grown. Enslaved Africans did most of the work on a plantation.

Today, many plantations tell the shared history of our country. All have fascinating stories of race, culture, families, and sacrifice.

What can I see if I visit a plantation?

Some plantations show you what life was like hundreds of years ago. As you might guess, kitchens were very different in the 1800s. Meals were cooked on an open hearth with heavy cast iron cookware. And, there was no running water or refrigeration, either!

...and there's more!

Other plantations today grow beautiful gardens or help preserve nature in other ways. The Latta Plantation in Mecklenburg County is now a nature center and preserve. This former cotton plantation is now part of an effort to protect more than 1,343 acres of natural habitats.

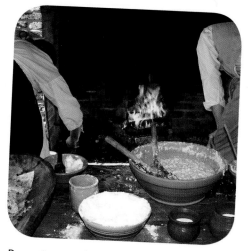

Preparing meals on a plantation was a lot of work.

The American Bald Eagle, like this one, is one of the many species of birds whose habitats are protected at the Latta Plantation Nature Preserve.

Well, how about...
the people!

Enjoying the Outdoors

More than nine million people live in the state of North Carolina. With so many people, you can be sure that there are lots of different opinions throughout the state. However, North Carolinians also have plenty in common.

Many share a love of the outdoors. The state has a mild climate, but it still has four seasons for people to enjoy. Surfing and swimming are popular at the Outer Banks in the summer, while skiing and snowboarding are favorite pastimes in the mountains in the winter. Hiking, fishing, golfing—the list of things that North Carolinians enjoy goes on and on!

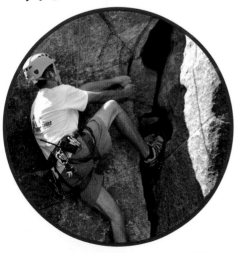

Rock climbing is a popular activity at Chimney Rock State Park.

Golfers love the many great courses in North Carolina.

Sharing Traditions

The state of North Carolina is rich in traditions. Crafts like quilting and basket weaving are passed down through the generations. Even storytelling is an art in many places throughout the state.

Did you ever wonder what a Revolutionary War battle was like? North Carolinians sometimes re-create battles to honor the history and heritage of brave soldiers. Cooking is another way to pass on traditions. Have you ever heard of Moravian Sugar Cake? How about Calabash-style seafood? North Carolina kitchens are full of cherished recipes!

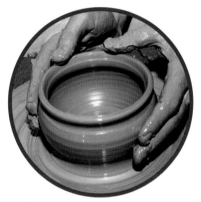

Pottery making in the Catawba Valley has been a traditional craft since colonial times.

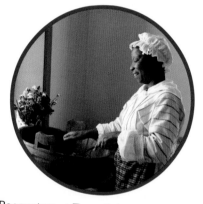

Reenactors at Tryon Palace demonstrate what life was like in the late 1700s, when New Bern was the first permanent capital of the colony of North Carolina.

North Carolinians appreciate the beauty of the land around them.

Protecting

Without conservation efforts, the river otter might have disappeared from North Carolina. You can learn about them at the North Carolina Aquarium—which has three locations in the state.

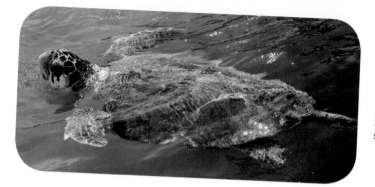

The Karen Beasley Sea Turtle Rescue and Rehabilitation Center is in Topsail. Its mission is to conserve and protect sea turtles like the loggerhead shown here.

Protecting all of North Carolina's natural resources is a full-time job for many people!

Why is it important to protect North Carolina's natural resources?

The many different environments in North Carolina help shape its character. Life along the coast moves in rhythm with the tides and the water. Activities in the mountains are often dictated by altitudes and seasons. All these different environments also mean that many different plants and animals can live throughout the state. In technical terms, North Carolina has great biodiversity! This biodiversity is important to protect because it keeps the environments balanced and healthy.

What kinds of organizations protect these resources?

It takes a lot of groups to cover it all. The U.S. Fish and Wildlife Service is a national organization. The state's main environmental agency is the Department of Environment and Natural Resources. The state's park system is part of this agency.

Education programs at the North Carolina Zoo in Asheboro teach visitors about different animals and their habitats.

And don't forget...

You can make a difference, too! It's called "environmental stewardship"—and it means you are willing to take personal responsibility to help protect North Carolina's natural resources.

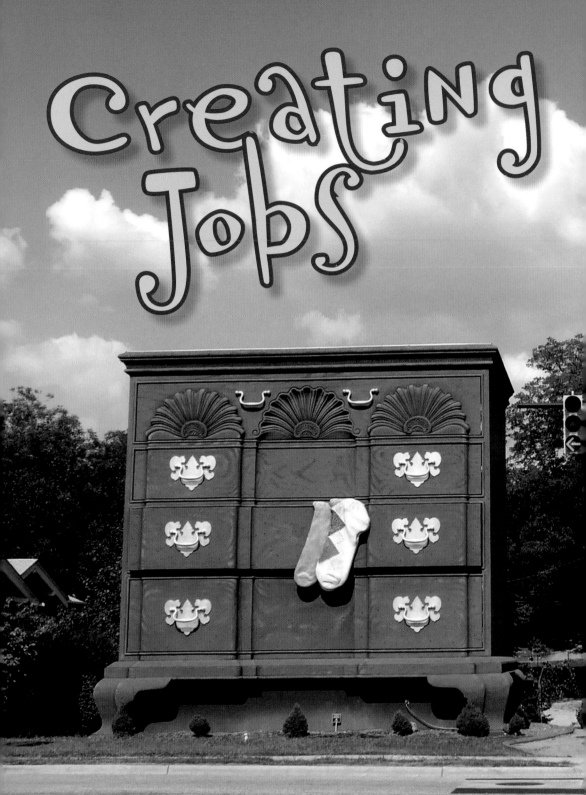

Creating Jobs

A gigantic chest of drawers in High Point—furniture manufacturing has been important in the state for a long time.

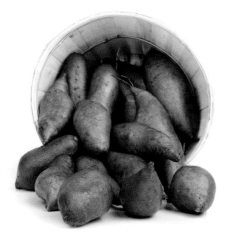

North Carolina grows more sweet potatoes than any other state.

Some jobs, such as farming, furniture making, and textile production have been done in North Carolina for a long time. Other jobs, such as filmmaking, medical research, and banking, are growing in demand.

Why is North Carolina a good place to work?

The state has great natural resources and energetic people! These two things help businesses grow.

What kinds of jobs are available throughout the state?

North Carolinians have always been good at making things. Today, many people work in the manufacturing industry. From furniture and fabrics to paper products, electrical machinery, computers, and chemicals, great products come through warehouses all over the state.

North Carolina is home to great medical and research facilities.

The state also has mineral resources and leads the nation in the production of materials made from feldspar, mica, and lithium.

Another big industry is the service industry. From chefs to tour guides, many jobs are needed to help tourists sightsee, eat, and relax!

Don't forget the military!

The Air Force, Army, Marine Corps, Navy, and Coast Guard can all be found in the state. North Carolinians have great respect for all the brave men and women who serve our country.

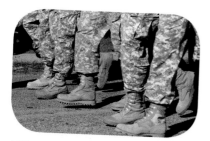

Military training is hard work!

Celebrating

Lots of People have fun at the North Carolina Mountain State Fair.

The people of North Carolina really know how to have fun! Not only do they celebrate the State Fair in Raleigh each year—they also have a Mountain State Fair in Fletcher as well.

Why are North Carolina festivals and celebrations special?

Celebrations and festivals bring people together. From cooking contests to art shows, events in every corner of the state showcase all different kinds of people and talents.

What kind of celebrations and festivals are held in North Carolina?

Too many to count! But one thing is for sure. You can find a celebration for just about anything you want to do.

Would you like a pickle? The Mount Olive Pickle Festival will provide you with free pickles and the opportunity to shake hands with the eight-foot pickle himself, Mr. Crisp.

How about a weather forecast from a woolly worm? Since 1978, the people of Banner Elk have been racing their worms at the Woolly Worm Festival. The winning worm has the honor of predicting the weather for the coming winter.

...and don't forget about the Hollerin' contest!

In earlier times, neighbors in the country often communicated by loudly calling across the fields. You might think it was yelling; but it was hollerin'. That tradition may have disappeared, but it is celebrated each year at the National Hollerin' Contest in Spiveys Corner.

Artistic statues of pigs are placed around the city of Lexington each year in a public art project called "Pigs in the City." The pig art sets the stage for Lexington's famous Barbecue Festival that takes place every fall.

You can enjoy grilled shrimp—and plenty of other seafood—at the North Carolina Seafood Festival in Morehead City.

25

Birds and Words

What do all the people of North Carolina have in common? These symbols represent the state's shared history and natural resources.

State Tree
Pine

State Bird
Cardinal

State Flower
Dogwood

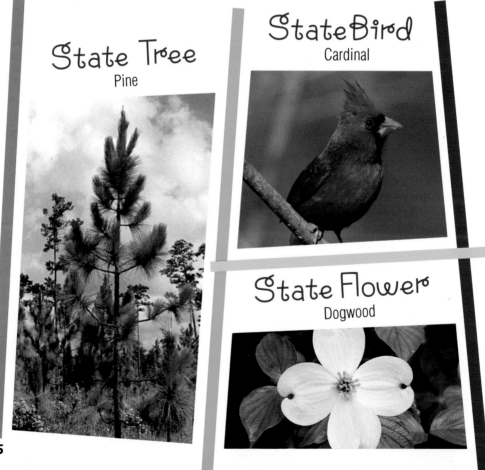

State Berries
Strawberry and Blueberry

State Flag

State Reptile
Eastern Box Turtle

State Mammal
Eastern Gray Squirrel

State Insect
Honeybee

State Stone
Emerald

Want More?

Statehood—November 21, 1789
State Capital—Raleigh
State Nickname—Tar Heel State
State Song—"The Old North State"
State Rock—Granite
State Beverage—Milk

State Fruit—Scuppernong Grape
State Vegetable—Sweet Potato
State Wildflower—Carolina Lily
State Carnivorous Plant—
Venus Flytrap
State Shell—Scotch Bonnet
State Motto—"*Esse Quam Videri*"
("To be rather than to seem")

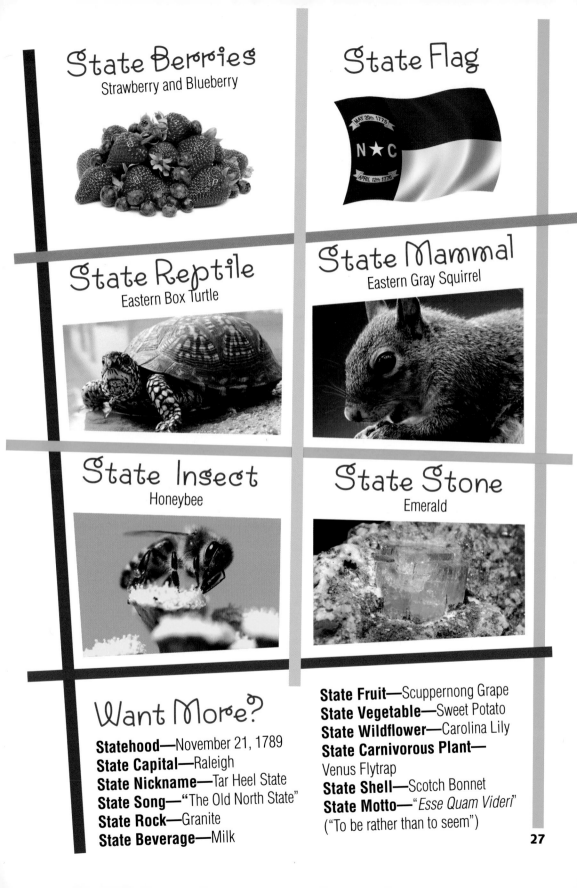

More Fun Facts

More

Here's some more interesting stuff about North Carolina.

The Northern Half

In 1629, King Charles I of England directedthat all the land from Albermarle Sound to the St. Johns River be called Carolana. His son, Charles II, changed the name to Carolina. When Carolina was eventually divided, the northern part became North Carolina.

The Lost Colony

A group of English colonists led by John White settled on Roanoke Island in 1587. When supplies ran short, White sailed back to England. However, when he returned to Roanoke in 1590, he found just a few remains of the colony. To this day no one is completely sure what happened to the colony and its settlers.

A Pirate's Cove

The notorious pirate, Blackbeard, stayed for a time in **Bath**—North Carolina's first established town.

First in Its Class

The first state university in the United States—the University of North Carolina—opened in 1795 in **Chapel Hill**.

Lights, Camera, Action

Some movies made in North Carolina include *Blue Velvet*, *The Color Purple*, *The Hunt for Red October*, *Days of Thunder*, and *Patch Adams*.

Fore!

The first miniature golf course in the United States was built in **Pinehurst** in 1916.

Right in the Center

The geographic center of North Carolina is in Chatham County, 10 miles northwest of **Sanford**.

Universities Unite

Three major research universities—Duke University in **Durham**, North Carolina State University in **Raleigh**, and the University of North Carolina in **Chapel Hill**—are part of North Carolina's Research Triangle Park.

Green with Envy

The largest emerald crystal ever found in North America came from the Piedmont area in North Carolina.

Brad's Drink

A cola invented in 1893 by Caleb Bradham of **New Bern** was first called "Brad's Drink." It later became known as Pepsi-Cola!

Bright Light

The **Cape Hatteras** Lighthouse is the tallest brick lighthouse in the United States.

Glazed Over

Krispy Kreme Doughnuts, Inc., was founded in **Winston-Salem**.

Coming Through!

The **Outer Banks** are part of the "Atlantic flyway," where thousands of birds can be spotted during their annual southward migration.

Bagpipe Brigade

Each year, Scottish clans get together in **Linville** at the Grandfather Mountain Highland Games. Competitions include the hammer throw and the clan tug-of-war!

Helping Madagascar

The Duke Lemur Center is the world's largest sanctuary for rare and endangered prosimian primates—including ring-tailed lemurs!

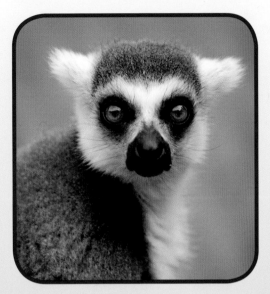

Shooting Par

Pinehurst is known for its beautiful golf courses. But between 1916 and 1920, Annie Oakley (the sharp-shooting star of Buffalo Bill's Wild West Show) was in charge of the Pinehurst Gun Club where she gave shooting exhibitions and lessons.

Born to Race

North Carolina has deep roots with NASCAR. The state is the birthplace and home of many NASCAR legends including Dale Earnhardt (both Senior and Junior) and Richard Petty.

Wild Rivers

North Carolina has some popular whitewater rafting rivers including the Nantahala and the French Broad rivers.

Find Out More

There are many great websites that can give you more information about the exciting things that are going on in the state of North Carolina!

State Websites

The Official Government Website of North Carolina
www.ncgov.com

North Carolina Highway Historical Marker Program
www.ncmarkers.com

North Carolina State Parks
www.ncparks.gov

The Official Travel and Tourism Site of North Carolina
www.visitnc.com

Museums/Asheboro

North Carolina Aviation Museum
www.ncairmuseum.org

Asheville

Ashville Art Museum
www.ashevilleart.org

Charlotte

North Carolina Mint Museum
www.mintmuseum.org

Cherokee

Museum of the Cherokee Indian
www.cherokeemuseum.org

Greensboro

International Civil Rights Center & Museum
www.sitinmovement.org

New Bern

Tryon Palace
www.tryonpalace.org

Raleigh

North Carolina Museum of Art
www.ncartmuseum.org

North Carolina Museum of History
www.ncmuseumofhistory.org

North Carolina Museum of Natural Sciences
www.naturalsciences.org

Wilmington

Battleship North Carolina
www.battleshipnc.com

Winston-Salem

SciWorks
www.sciworks.org

Aquariums and Zoos

North Carolina Aquariums
www.ncaquariums.com

North Carolina Zoo (Asheboro)
www.nczoo.org

Duke University Lemur Center (Durham)
www.lemur.duke.edu

North Carolina: At A Glance

State Capital: Raleigh

North Carolina Borders: South Carolina, Georgia, Tennessee, Virginia, and the Atlantic Ocean

Population: Over 9 million

Highest Point: Mount Mitchell at 6,684 feet above sea level

Lowest Point: Sea level at the Atlantic Ocean

Some Major Cities: Raleigh, Charlotte, Greensboro, Durham, Winston-Salem, Fayetteville, Cary, Wilmington, High Point, Asheville

Some Famous Tar Heels

Andy Griffith (born 1926) from Mount Airy; is an actor famous for his work on the long-running television series *The Andy Griffith Show* and *Matlock*.

Andrew Jackson (1767–1845) from the Waxhaw region; was the 7th President of the United States.

Junaluska (around 1775-1858) from Murphy area; was a Cherokee leader in western North Carolina.

Virginia Dare (1587–?) Roanoke Colony; was the first child born in the Americas to English parents.

Mary Elizabeth Dole (born 1936) from Salisbury, NC; is an American politician who became the first woman United States senator from North Carolina.

(Ralph) Dale Earnhardt Sr. (1951–2001) from Kannapolis, NC; was an American race car and NASCAR Hall of Famer.

Roberta Flack (born 1937) from Black Mountain, NC; is a Grammy-winning jazz and R & B singer.

Dolley Madison (1768–1849) from Guilford County; was First Lady of the United States (1809-1817) as the wife of the 4th President of the United States, James Madison.

James K. Polk (1795–1849) from Mecklenburg County; was the 11th President of the United States.

Charles Kuralt (1934–1997) from Wilmington; was an Emmy- and Peabody-award-winning journalist and television host.

Hiram Rhoades Revels (1822–1901) from Fayetteville; was the first African American member of the United States Congress.

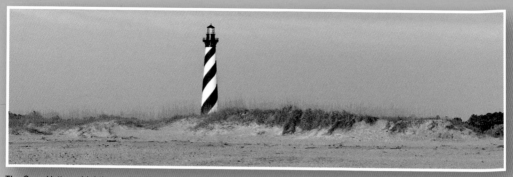

The Cape Hatteras Lighthouse is a National Historic Landmark.

CREDITS

Series Concept and Development
Kate Boehm Jerome

Design
Steve Curtis Design, Inc. (www.SCDchicago.com); Roger Radtke, Todd Nossek

Reviewers and Contributors
Content review: Michael Hill and Ansley Wagner, North Carolina Office of Archives and History; Contributing writers/ediotrs: Terry B. Flohr; Stacey L.Klaman; Research and production: Judy Elgin Jensen; Copy Editor: Mary L. Heaton

Photography

Back Cover(a), Cover(d), 9b © Kenneth Wiedemann/iStockphoto; Back Cover(b), 10-11 Used with permission from The Biltmore Company, Asheville, North Carolina; Back Cover(c), 13b © David Ross/Shutterstock; Back Cover(d), Cover(a), 3b © Dave Allen Photography/Shutterstock; Back Cover(e) © Patrick Johnson/Shutterstock; Cover(b), 26(c) © Jonathan Larsen/Shutterstock; Cover(c), 2a © iofoto/Shutterstock; Cover(e) © Robert Ranson/Shutterstock; Cover(f) © Matej Krajcovic/iStockphoto; 2-3 © Eric Foltz/iStockphoto; 2a © Eldin/Shutterstock; 3a © Tim Mainiero/Shutterstock; 4-5 © jadimages/Shutterstock; 5a © Jorge Moro/Shutterstock; 5b © David Huntley/Shutterstock; 6-7 Courtesy Visit Lake Norman; 7a © Ryan M. Bolton/Shutterstock; 7b © Nick Martucci/Shutterstock; 8-9 By Matt Mutel, Courtesy NC Division of Parks and Recreation; 9a Ken Thomas/Wikimedia; 10a © Courtesy of the Eastern Band of Cherokee Indians; 11a © Lawrence Roberg/Shutterstock; 11b Courtesy Charlotte Hawkins Brown Museum, State Historic Sites, NC Dept. of Cultural Resources; 12-13 © Kevin Borland; 13a © Don Kennedy; 14-15 Courtesy North Carolina Transportation Museum; 15a © Paul MacKenzie/iStockphoto; 15b © Cre8tive Images/Shutterstock; 16-17 by James Veverka, Courtesy Hope Plantation; 17a By Jean Davis Olecki; 17b © Don Fink/Shutterstock; 18-19 © Bonita R. Cheshier/Shutterstock; 18a Courtesy Chimney Rock at Chimney Rock State Park; 18b © Jerry Zitterman/Shutterstock; 19a © Mikhail Olykainen/Shutterstock; 19b (Interactive historical interpreter) Courtesy Tryon Palace, North Carolina; 20-21 © Štěpán Ježek/iStockphoto; 21a © Mihai Dancaescu/Shutterstock; 21b N.C. Zoo photo; 22-23 By Brady Stern; 23a © CREATISTA/Shutterstock; 23b © l i g h t p o e t/Shutterstock; 23c © John Wollwerth/Shutterstock; 24-25 By Susan Lee (leewaydesign.com); 25a By Dwayne Padon; 25b © Korolevskaya Nataliya/Shutterstock; 26a USDA Forest Service; 26b © Doug Lemke/Shutterstock; 27a © Kim Reinick/Shutterstock; 27b © Pakmor/Shutterstock; 27c © Constance McGuire/iStockphoto; 27d © Redwood/Shutterstock; 27e © Daniel Prudek/Shutterstock; 27f © Terry Davis/Shutterstock; 28a © artcalin/Shutterstock; 28b © Dewitt/Shutterstock; 29 © Karen Hadley/Shutterstock; 31 © R. Gino Santa Maria/Shutterstock; 32 © Jorge Moro/Shutterstock

Illustration
Back Cover, 1, 4, 6 © Jennifer Thermes/Photodisc/Getty Images

ISBN 978-1-58973-017-5

Library of Congress Catalog Card Number: 2010935881

1 2 3 4 5 6 WPC 15 14 13 12 11 10

Published by Arcadia Publishing, Charleston, SC

For all general information contact Arcadia Publishing at:

Telephone 843-853-2070

Fax 843-853-0044

Email sales@arcadiapublishing.com

For Customer Service and Orders:

Toll Free 1-888-313-2665

Visit us on the Internet at www.arcadiapublishing.com